# Early Celtic Art
# in Ireland

Eamonn P Kelly

Country House, Dublin
in association with
The National Museum of Ireland

Published in 1993 by
Town House and Country House
42 Morehampton Road
Donnybrook
Dublin 4
Ireland

in association with The National Museum of Ireland

Text copyright © National Museum of Ireland, 1993

British Library Cataloguing in Publication Data. A catalogue record for this book is available from the British Library.

ISBN: 0-946172-34-X

*Acknowledgements*
The author and publishers would like to thank the following for permission to reproduce their photographs: The Office of Public Works for Plates 9 and 12; The Board of Trinity College Dublin for Plate 17. All the other photographs belong to the National Museum of Ireland.

Design: Bill Murphy
Origination: The Kulor Centre
Printed in Ireland by ßetaprint

# CONTENTS

The Celts                                          5
La Tène art                                        6
The Broighter Hoard                               10
Iron and bronze spearheads                        11
The Petrie Crown and Cork Horns                   14
The Somerset Hoard                                15
Decoration with glass and enamel                  34
Figures and heads                                 37
Horses and chariots                               39
The Lambay finds                                  41
The Roman influence                               42
Ultimate La Tène art                              43

*Glossary*                                        47
*Select bibliography*                             47

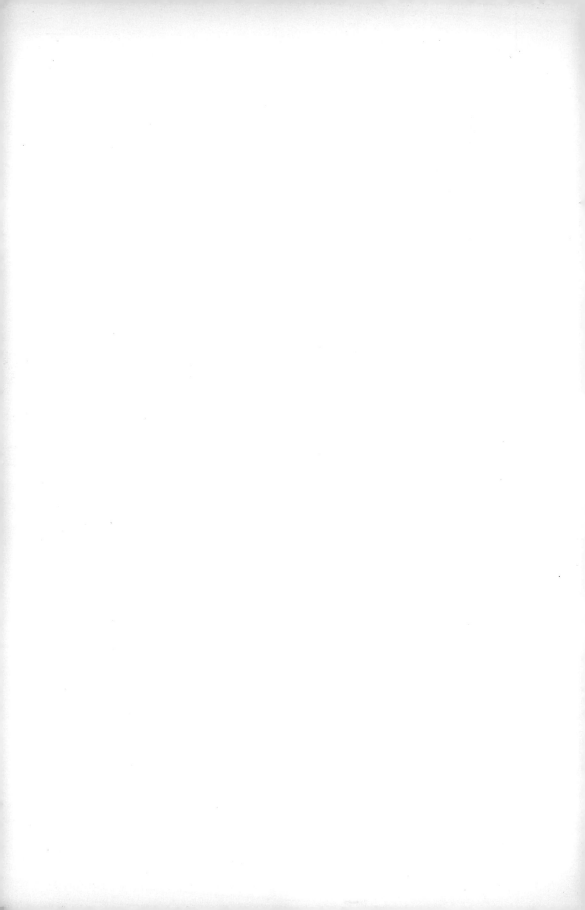

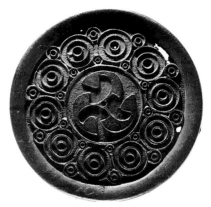

The pre-eminent culture of the Late Bronze Age in central Europe was the Hallstatt culture (named after the Austrian village where characteristic burials and artefacts were found in the nineteenth century), which adopted an iron-using technology around the beginning of the seventh century BC. This new development did not immediately result in any radical upheaval: rather there was a continuous cultural development.

During the seventh and sixth centuries BC, through the medium of trade, later Hallstatt communities came into close contact with the classical world of the Greeks and the Etruscans. Although a range of commodities was exchanged, salt — of which the Alpine region had rich deposits — was a product much sought after in the Mediterranean climate to the south because of its preservative qualities. One important commodity the Greeks and Etruscans were willing to exchange for salt was wine. This they traded, together with drinking vessels and other elaborate utensils. The Greeks operated the trade from Marseilles, and their main route north was along the valley of the Rhône, thence north-east along the valley of the Saône. The Etruscans, from their settlements in northern Italy, traded along routes that followed the Alpine passes.

Other important cultural influences resulted from contact with the nomadic people of the steppes. Through contact with the Cimmerians the skills of horsemanship and archery, as well as new burial customs, appear to have been introduced. The Cimmerians had been displaced by another powerful steppe people, the Scythians, who by the seventh century BC were extending their range into parts of central and western Europe. The later arrivals possessed an animal art whose range extended from the western steppes to Siberia.

## The Celts

The people of central Europe involved in these trading and cultural exchanges were known to the Greeks as 'Keltoí' or Celts. An area extending from Austria to eastern France, including parts of Switzerland and south Germany, formed the core area of the Hallstatt culture, whose influence extended over an area stretching from Portugal in the west to Bohemia in the east. South-eastern England may also be regarded as forming part of the wider Hallstatt province.

At this time Ireland had a flourishing native Late Bronze Age culture, known as the Dowris phase (after a site in Co Offaly where a hoard of tools and weapons of the period was found). Some Hallstatt influences reached Ireland before the end of the seventh century BC, probably by way of southern Britain. A new type of bronze sword appears, which is an insular version of a continental form. Other objects believed to

have a Hallstatt origin are 'chapes' — fittings at the end of sword scabbards to prevent the point from piercing through. Three cast bronze bracelets found in Co Antrim and two unlocalised examples of the so-called 'nut-moulded' type are of Hallstatt origin. So also is a penannular bracelet from Kilmurry, Co Kerry, which has knobbed terminals, and certain ritual objects known as flesh-forks, the best example of which was found at Dunaverney, Co Antrim.

Around 500 BC the civilisation of the Dowris phase collapsed. The reasons for this appear to have been complex, but one element may have been the presence of intrusive Hallstatt groups who are but faintly represented in the archaeological record.

## La Tène art

For the most part the indigenous art of central and western Europe, including Ireland, was based on simple geometric forms that had continued in use from Late Stone Age times. Towards the end of the Hallstatt period classical art began to exert a powerful influence over the work of native craftworkers. It was not the naturalistic art of the Greeks that awakened their creative talents but minor themes, mainly vegetable and foliage designs, which came to be reinterpreted and reworked by Celtic artists into a dynamic new art style. Other elements, such as the tradition of representing human faces or masks, were borrowed from the Etruscans, and from the Scythians were borrowed certain elements of oriental animal art.

The new art developed after the middle of the fifth century BC, and its emergence followed a period of disruption and population movement in central Europe. The focus of the new developments was in the Rhineland and eastern France, to the north of the old Hallstatt heartland. Known as the La Tène style (after the site in Switzerland where it was first recognised), the new art was one of the crowning achievements of Celtic civilisation. Leafy palmette forms, vines, tendrils and lotus flowers were favourite motifs, together with spirals, S-scrolls, and lyre and trumpet shapes. The style, which was given expression on the personal ornaments and weapons of a warrior aristocracy, was diffused over a wide area by the actions of warlike bands, although the earliest La Tène style is not represented in Ireland.

Around 400 BC the La Tène Celts crossed the Alps and attacked northern Italy, and by 387 BC they stood before the gates of Rome. A century later they plundered Delphi before going on to invade Asia Minor. By the end of the fourth century BC La Tène colonists had reached Britain, and during the third century BC objects bearing distinctive La Tène designs began to appear in Ireland. It seems probable that these were associated with incursions of people, perhaps small warrior bands. Two gold neck ornaments known as the Clonmacnoise collars, discovered in a bog at Knock, Ardnaglug, Co Roscommon, are among the earliest finds. Neck ornaments are frequently present in Early La Tène graves on the Continent, and although most are of bronze there are also some elaborately decorated gold examples. Representations of warriors, naked but for their collars, are known, the most famous being the statue of the

Dying Gaul from Pergamum. Representations of gods wearing collars are also known, such as a bronze statuette of a human figure with the feet of a deer — believed to be the fertility god Cernunnos — from Bouray, France.

Whereas most collars have a gap in the ring, the more elaborate of the two Clonmacnoise collars does not (Photo 1). It is of a type characterised by its 'fused-buffer' terminals, comparable examples of which have been found on the Continent. This feature is flanked on each side by cone-shaped mouldings, and all three features bear decoration that has been hammered up from behind using the repoussé technique. The motif employed on the buffer is a continuous series of raised S-shapes that terminate in round bosses. On the flanking features spirals are employed, again terminating in raised circular bosses. The background is stippled to accentuate the repoussé designs. A box-like feature at the back of the collar allowed both halves to pivot, enabling the wearer to place it in position. The sides of this feature are depressed, being alternately elliptical and hourglass in shape, and a meandering gold wire frames the edges.

The decoration on the collar is comparable to that on gold ornaments found in the grave of a man and woman at Waldalgesheim in the Rhineland, and it is probably in this area that the Clonmacnoise collar originated. Waldalgesheim gives its name to the mature La Tène art style, which dates from the second half of the fourth century BC.

The second collar (Photo 2) consists of a twisted narrow band of gold with two hollow

*Photo 1 Gold collar with fused-buffer terminals from the so-called Clonmacnoise Hoard, found in a bog at Knock, Ardnaglug, Co Roscommon. Made in the Rhineland and dating from the third century BC, it is the earliest example of La Tène art found in Ireland.*

*Photo 2 Twisted gold collar with knobbed terminals, one of a pair known as the Clonmacnoise collars, found in a bog at Knock, Ardnaglug, Co Roscommon. Third century BC.*

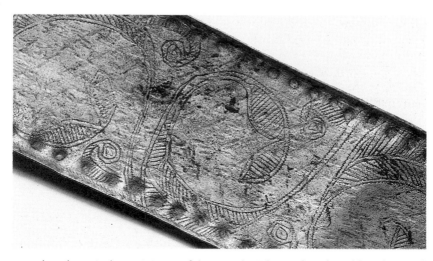

pear-shaped terminals, reminiscent of those on the Kilmurry bracelet. Although twisted gold collars are known from La Tène contexts on the Continent, they had been in use in Ireland from as early as 1200 BC. The discovery of another twisted gold collar in the later hoard of La Tène objects found in Somerset, Co Galway, appears to confirm that the two Clonmacnoise collars can be regarded as a genuine association.

Possibly by the end of the third century BC, and certainly before the end of the second, craftworkers in Ireland were producing decorated metalwork whose immediate ancestry lay in central Europe. A group of eight bronze scabbard plates are known from north-east Ulster that bear engraved ornament ultimately of Waldalgesheim ancestry and that show influences from as far away as the middle Danube. The engraved designs of the so-called 'sword style' are in the form of stylised plant ornament, laid out in a series of S-scroll or lyre shapes. One such plate was found near the River Bann at Toome Bridge, Co Antrim, and although it is cruder than some of the other examples it was clearly a prized possession (Photo 3). The decorated surface originally faced outwards; later the scabbard plate was reversed and shortened, perhaps because of damage to the end. The decorated surface was worn by the sword blade as it was withdrawn and replaced. The etched lines consist of tiny continuous chevrons produced by an engraving tool known as a 'walked scorper'. A single design of stylised foliage is repeated from top to bottom along the plate, each part of the design a mirror image of the one above it. The plate has a characteristic outline, being bow-shaped at the broad end with a tapering narrow tongue at the other extremity.

Chapes were also being produced, and a fine example in cast bronze, which may have been unfinished, is that from near Roscrea, Co Tipperary. Like the other five known examples, it is lozenge-shaped at the end, rather resembling a stylised serpent's head, with extensions above the waisted centre. Circular settings at the widest part of the lozenge — the serpent's eyes — may have held studs, possibly of red enamel. An

origin in north-east France has been proposed for these chapes.

A direct continental origin, probably in southern or south-western France, is likely for the remarkable cast bronze sword hilt found in Ballyshannon Bay, Co Donegal, around 1916 (Pl 1). When found it was attached to a short iron blade about 375 mm (15 in) long. The hilt is in the form of a male human figure, perhaps a warrior or a god. Classical influence is clear in the modelling of the face, although the hair is depicted by means of the typically Celtic technique of vertical ridging. A horizontal band across the forehead has been interpreted as a leaf-crown, such as that on a figure on a Celtic stone pillar at Pfalzfeld, Germany, but it may just as easily represent textile or curled hair. The eyes are slanted. The grip is ridged by three short reel-shaped mouldings, whose surfaces are decorated with short engraved lines such as are known from the handles of bronze flagons found in a burial at Basse-Yutz, France.

In all, about two dozen Irish swords of this period are known to exist. The La Tène Celts in Ireland worked iron, but the techniques of impregnating the iron with carbon to produce steel were not apparently well known; this meant that the iron was relatively soft, which probably accounts for the fact that the weapons are invariably short, usually less than 500 mm (20 in).

Two basic types of sword are known, one of which has a curved hilt guard of organic material. This probably represents a local development of the La Tène form, and its immediate background appears to lie in Romano-British contexts. The second type, closer to the continental prototype, has a characteristic bell-shaped hilt guard. One well-preserved sword is that from Ballinderry, Co Westmeath, which is an exceptional 580 mm (23 in) in length. The cast bronze hilt guard is decorated on each face by two pairs of raised trumpet-and-lentoid motifs, which are emphasised by background stippling.

From this material it can be seen that during the last few centuries before Christ, continental Celtic sources appear to have been of great importance as an inspiration for Celtic craftworkers in Ireland. The expansion of the Roman empire overwhelmed the indigenous culture of the Celtic peoples of continental Europe, and indeed may have resulted in the flight of refugees to Ireland. Britain had been invaded twice by Julius Caesar during the first century BC, but these were temporary incursions; it was again invaded during the middle of the first century AD, this time by troops of the Emperor Claudius. This was invasion in earnest, and the Romans eventually succeeded in expanding the empire as far north as lowland Scotland. During the centuries after the birth of Christ it is to northern and possibly western Britain that we must mainly look for possible external Celtic influences on Ireland. Given the classical origins of much of Celtic art, it should be expected that the proximity of the empire might result in the introduction of new classical elements into insular Celtic art as well as the direct import of prestigious Roman objects.

This is not to suggest that it was necessary for Irish Celtic artists and craftworkers to have prototypes to copy, or indeed that ideas that were adopted were slavishly reproduced. By the end of the first century BC the Irish had fully absorbed the styles

and techniques of La Tène art, which they were capable of applying brilliantly, often on objects that are uniquely Irish types.

### The Broighter Hoard

The gold objects found by a ploughman at Broighter, Co Derry, well illustrate the unique style of Irish La Tène art. The hoard consists of a model boat together with its fittings, a gold bowl with rings for suspension, two chains, and two twisted bracelets. A large collar with buffer terminals was also found. It has been suggested that the hoard is a votive deposit to the Celtic sea god Manannán mac Lir, after whom the Isle of Man came to be named.

The Broighter collar (Pl 2) is clearly of local manufacture, and it constitutes one of the great masterpieces of European Early Iron Age art. It is complete except for its rear moulding and the applied decoration from one of its buffer terminals. The ring consists of two semi-circular tubes formed from sheets of gold. On their convex surfaces, relief decoration that may be regarded as a late insular form of the continental 'plastic style' was achieved by chasing: the motifs were defined by incised lines and brought into relief by depressing the background (Pl 3). The main technique was hammering, and the surface was then polished to remove the hammer marks.

The decoration consists of an intricate foliage design of complex symmetry, the main framework of which appears to be based on the lotus-bud motif. It comprises a series of interconnecting S-scrolls incorporating extended trumpets defined by lentoid bosses. These terminate in leaf-shaped comma motifs mounted with exaggerated roundels resembling snail shells, which were separately made and attached. The area between the raised decoration is filled with concentric arcs applied with a compass, serving to emphasise the raised decoration. The ends of the tubes adjoining the terminals each bear a single row of small punched-up pellets. These appear to be an attempt at disguising the heads of the rivets that secure the joint.

The feature at the back of the collar that would have secured the tubes to some form of swivel, similar to that on the Clonmacnoise collar, is missing. The tubes are riveted to two short cylinders that are soldered to the terminals; these terminate in a mortise-and-tenon arrangement that fastened the collar. The T-shaped tenon is surrounded by raised lines arranged like a sunburst. The areas between the terminals and the joints with the tubes bear raised ornament with trumpets, lentoid and circular bosses. The circular bosses are dished; each one bears an inscribed circle, with a gold ball soldered at the centre of each.

The fact that the decoration on the ring is chased rather than repoussé results mainly from the technical difficulties involved in producing the object. However, it also suggests a continuity of native craft traditions from the Later Bronze Age, for the basic techniques of working relief decoration in gold from the front had long formed part of the repertoire of Irish goldsmiths. This is evidenced by the work on a gold collar from Gleninsheen, Co Clare, which is dated to around 700 BC. The use of rows of pellets to

*Photo 4 Bronze figure
of an Etruscan warrior
found in Co
Roscommon, one of a
number of
Mediterranean imports
that reached the north-
west of Ireland during
the second and first
centuries BC.*

disguise rivet heads on the Broighter collar also harks back to earlier days, for it is reminiscent of the manner in which the rivet heads on a bronze shield from Lough Gur, Co Limerick, were rendered inconspicuous by being placed in a row of repoussé bosses. The shield also dates from around 700 BC.

It is certain from the decoration and workmanship that the Broighter collar is of Irish manufacture, although the type originates on the Continent. The mortise-and-tenon fastening device is found on a number of continental collars. The Broighter collar may be viewed as the main point of departure for all later examples of Early Iron Age art in Ireland.

By contrast with the collar, the two gold chains are exotic imports, possibly from Roman Egypt (Pl 4). Other objects of Mediterranean origin that should be considered in relation to the Broighter chains are bronze figurines of Etruscan origin dating from the second or first century BC (Photo 4). Two unlocalised examples are of Hercules; the other two, from Co Sligo and Co Roscommon, are not readily identified, but some significance may attach to their distribution, which, like Broighter, lies in the north-west of the country.

A Roman background is likely for the two twisted bracelets in the Broighter Hoard, the best parallels for which are a pair from a hoard of Roman objects found at Newgrange, Co Meath. The unique gold boat is a model of an ocean-going vessel complete with seats, oars, rowlocks, steering oar, and mast (Pl 5). It has been suggested that the small gold bowl may also be a model, in this case of a cauldron (Pl 6). Full-sized cauldrons of the period are known, and these are generally made from bronze. An iron example is known from Drumlane, Co Cavan, and a remarkable wooden example, carved from a single block of poplar, was found at Altartate Glebe, Co Monaghan. A band of incised decoration consisting of gapped concentric circles and straight lines encircles the latter below the rim, and this may be related to decoration on the socket of a bronze spearhead from Boho, Co Fermanagh.

### Iron and bronze spearheads

In Ireland, spears rather than swords appear to have been the characteristic weapon of the Celtic warrior. The spearheads, which were mainly of iron, are difficult to distinguish from those of other periods, particularly when they are heavily corroded.

The remarkable decorated bronze spearhead found at Boho, Co Fermanagh, is of Early Iron Age date. The blade is leaf-shaped, while the socket is octagonal in cross-section. Both faces of the blade are decorated with incised angular and concentric-circle motifs.

Four small sub-triangular openings are an integral part of the decorative scheme. The straight-line and concentric-circle decoration on the socket, which has been compared to that on the Altartate Glebe cauldron, may also be related to that on the socket of an iron spearhead found near Corrofin, Co Clare (Photo 5). Like the Boho spearhead, it has perforations in the blade, although they are oval and are inset with bronze. The fretwork decoration may also be compared to that on cylindrical bronze ferrules on wooden spear-shafts found at Lisnacrogher, Co Antrim. Three have fret patterns, which sometimes end in circular expansions, while a fourth is decorated with interlocking S-figures that end in cone-shaped depressions.

Sixty-seven bronze spear-butts are known from Ireland, and many of them are exceptional products of the bronzeworker's craft. All but two of nineteen examples of the Lisnacrogher type were found on the Co Antrim site after which they are named. It seems likely that they are the product of a single workshop, probably in the immediate vicinity. They have a waisted cylindrical shape with an expanded base and a moulding set slightly below the mouth of the socket. One example is elaborately decorated with raised interlocking S-shapes on the moulding and by curvilinear decoration on the expanded base. The tubular type, of which eighteen examples are known, are more elaborately ornamented, and generally have a moulding at each end of a tapering body. Below the socket moulding, in a number of examples, incised decoration occurs, some of which formerly held inlays of red enamel. Two examples, one from the River Shannon and the other unprovenanced, have incised curvilinear decoration that may represent stylised human mask forms.

Elaborate shields such as are known from Celtic Britain have not been found in Ireland, although a plain but elegant example made from leather-covered wood is known from Clonoura, Co Tipperary. It is rectangular and has a rectangular boss.

Classical writers have left accounts of the unnerving effect on Roman armies that the

continental Celts achieved by blowing their war trumpets before a battle. A large
trumpet is represented beside the Dying Gaul from Pergamum. Trumpets of this type
have been found at Ardbrin, Co Down, and Roscrea, Co Tipperary; but the most
outstanding Irish example, which dates from the first century BC, is that recovered
from a former lake known as Loughnashade in Co Armagh (Photo 6). The lake was
close to the great Celtic site of Eamhain Mhacha or 'Navan Fort', traditionally the seat
of the kings of Ulster, and four trumpets were found here during the last century. Only
one has survived, and it consists of two curved tubes whose joining is concealed by a
ridged ring. There is a decorated ring at the flared mouth. Both tubes are riveted along
their length. One tube, which is clearly a later replacement, is poorly executed, while the
other is a masterpiece of the metalworker's craft. The quality of the riveting is of a
standard that is only occasionally matched on other fine metalwork, such as the Petrie
Crown and the Cork Horns. The ornament, executed in the repoussé technique, is
based on the classical lotus-bud motif. The quadrants are mirror images of each other,
and the design is composed of long sinuous tendrils that terminate in spiral bosses in
high relief. A number of trumpet curves are incorporated into the design.

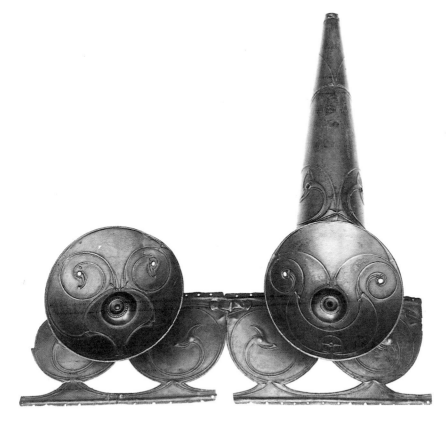

*Photo 7 Decorated
bronze head-dress
known as the Petrie
Crown. The metal
components would have
been sewn to a base of
leather or cloth. The
object probably dates
from the first century
AD and may have been
worn on ritual
occasions.*

### The Petrie Crown and Cork Horns

Details of the discovery of the Petrie Crown are not known. It is named after George Petrie, the nineteenth-century antiquary in whose collection it had been for many years (Photo 7). The bronze components formed part of an elaborate horned head-dress. One cone survives, attached to a dished roundel, and evidence for another can be seen on the back of a second roundel. The roundels are attached to plates that have openwork voids, creating the impression that they are composed of running semi-circles.

The Petrie Crown is related to three decorated bronze cones known as the Cork Horns, and possibly to two undecorated bronze cones found in a bog at Runnabehy, Co Roscommon. Similar examples of horned head-dress are unknown outside Ireland, although a Celtic bronze horned helmet is known from the River Thames, and representations of Celtic warriors wearing similar helmets are known on the Continent, particularly in Roman contexts.

The Irish objects suggest a ritual rather than a martial purpose, and clues to their possible religious significance may be gleaned from finds made on the Continent. A great silver cauldron found in a bog at Gundestrup, Denmark, shows a human figure wearing deer antlers, and this is likely to be the fertility god Cernunnos, who is also represented on the bronze figure from Bouray referred to earlier. The Irish objects were probably worn on special religious occasions and associated with concepts of fertility and renewal.

The decoration on the Petrie Crown and the Cork Horns relates both of them to a bronze disc found in the River Bann in Co Derry. The three objects probably date from the first or second century AD, and on all three the decoration was achieved by casting. The Cork Horns are decorated with curvilinear ornament formed of fine sinuous trumpet shapes, which terminate in lentoid bosses. That on the central horn is based ultimately on the lotus-bud motif, although it compares closely to the mask-like designs noted earlier on two tubular spear-butts. The designs on the Petrie Crown are based on palmette and lotus-bud motifs, and again consist of sinuous trumpet forms terminating in lentoid bosses. However, the decoration on the Petrie Crown and the Bann Disc includes spirals that terminate in bird heads. Those on the cone and discs of the crown were once filled with red enamel, as were settings in the bosses on the discs, one of which still contains an enamel stud.

The bird-headed motif is very characteristic of Celtic art in Ireland and continued to be popular almost until the end of the first millennium AD. Birds were frequently represented in continental Celtic art as far back as Hallstatt times, but it is probably to northern Britain that one must look to find the immediate source of the designs on the Petrie Crown and Bann Disc. Three different types of bird head are represented on the Petrie Crown, and those on its cone are remarkably similar to decoration on British 'dragonesque' brooches.

### The Somerset Hoard

The themes of continuity and innovation are both represented in the remarkable collection of objects found at Somerset, Co Galway. This consisted of three shallow cylindrical bronzes, one placed within another to form a circular box (Photo 8). The box contained a twisted gold collar and a small openwork cylindrical bronze object, with enamel. Also found were a similar bronze object, though without enamel; a brooch or fibula made like a safety pin; a bronze cup handle, terminating in a bird's head; and a finger-shaped ingot and a metal cake, both of bronze. Some iron objects of unknown type that appear to have formed part of the hoard were discarded by the finder. Recently two further bronzes were found that also appear to have been associated with the hoard. One is a strip of sheet metal; the other is a terminal of a so-called 'Y-shaped piece'. The object, when complete, would have been one of a pair used to harness ponies to a chariot.

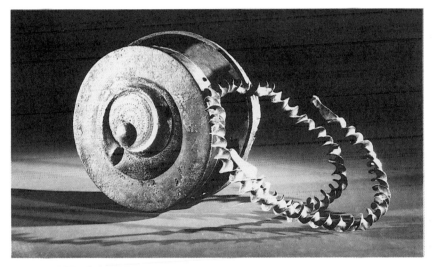

*Photo 8 Circular bronze box decorated with repoussé ornament and a twisted gold collar that was stored inside the box. The objects formed part of a hoard, probably that of a metalworker, dating from the first century AD and discovered at Somerset, Co Galway.*

As we have seen, the twisted gold collar is of a type that was in use in Ireland from the beginning of the Later Bronze Age. The circular bronze 'box' is a new type that is apparently unique to Ireland. The lid has a circular raised area bearing repoussé ornament. A trumpet pattern coils around a small central boss and terminates in a lentoid boss. The area within the trumpet pattern bears a series of incised concentric circles, the spaces between alternate circles being filled with equally spaced punched marks. The remainder of the raised central area is similarly dotted, and this technique recalls the work on the terminal of the Clonmacnoise buffer-terminal collar. The lid of the second Somerset box had an openwork design, now missing.

The function of the two smaller but similar objects is uncertain. Each has openwork decoration, at the centre of which are S-shaped forms. A domed stud of red enamel

underlay the centre of the one found inside the sealed box.

Red enamel also occurs on a series of studs on the safety-pin brooch from Somerset. The brooch has the outline of a bull's head, and the shape may not be fortuitous. Although a larger number of safety-pin brooches are known in Ireland, some of which appear to be imports, only six are known of precisely the same type as that from Somerset. They are known as Navan-type brooches after Navan Fort, near which two were found. It is interesting to recall that this site is central to the great epic tale 'Táin Bó Cuailgne' (the Cattle Raid of Cooley), which features magical bulls. The bull-like outline of the smaller of the two brooches from Navan is particularly striking. The second had a stud of red enamel similar to those on the Somerset brooch (Photo 9).

*Photo 9 Bronze safety-pin brooch or fibula found near Eamhain Mhacha (Navan Fort), Co Armagh. The central setting would have held a red enamel stud.*

In addition to the safety-pin forms, straight pins with either a bent back or ring-headed end also occur in Ireland. Ultimately they derive from continental Hallstatt pins, although a British background appears likely for the Irish series. There are four Irish types, of varying degrees of complexity, and although some are highly stylised or elaborate they are all based ultimately on a representation of a swan's neck. On a pin from the River Shannon the bird-like character is clearly evident, and this relates it to the Somerset cup handle. This handle, which terminates in a bird's head, is for a drinking vessel, and is similar to those on bowls found at Keshcarrigan, Co Leitrim, and Fore, Co Westmeath.

More than a dozen related bronze bowls have been found in Ireland. They are similar to southern British types, and some are actual imports. The vessel found containing a cremation burial within a hill-fort at Fore originally had two small bird-headed handles, one of which is now lost (Pl 7). The vessel was made in two parts from sheet bronze, and the joining along the middle is decorated with a row of domed studs. It is similar to a vessel found in a Celtic burial at Spettisbury Rings, Dorset, and probably represents an import from southern England during the century preceding the Claudian invasion.

The Keshcarrigan bowl (Pl 8) is also likely to be an import from the south of England, although it appears to date from slightly later, perhaps from the early half of the first century AD. The vessel was first beaten into shape and then finished by the exertion of pressure on the surface while the object was being spun into a wooden mould. It turns in at the shoulder and has an out-turned rim decorated with a zigzag line in false relief produced by hammering. The cast handle is in the form of a duck-like

*cont. p 33*

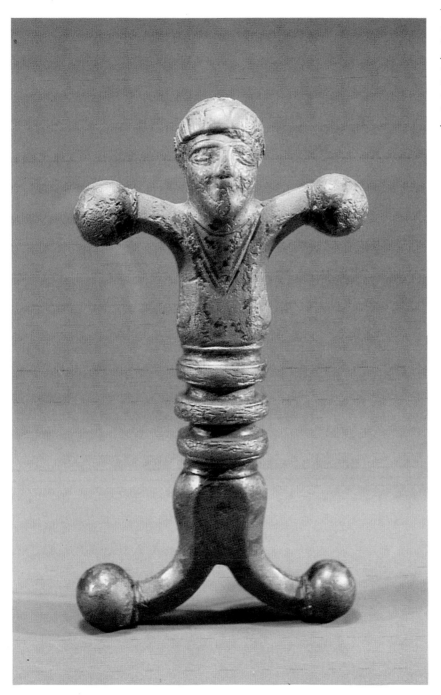

*Pl 1 Bronze sword hilt dredged by a trawler from the sea bed in Ballyshannon Bay, Co Donegal. Dating from the first century BC, the object is an import from southern or south-western France.*

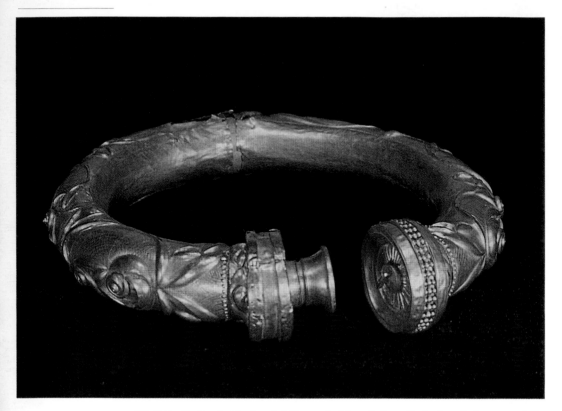

*Pl 2 Gold collar found with a hoard of objects at Broighter, Co Derry. Dating from the first century BC, the collar is one of the greatest masterpieces to have been produced by Celtic craftworkers anywhere in Europe.*

*Pl 3 (Facing page) Detail showing the raised curvilinear decoration, set off by a field of incised arcs, on the ring of the Broighter collar. One expert believes that the raised decoration represents a stylised horse, an animal sacred to the sea god Manannán mac Lir.*

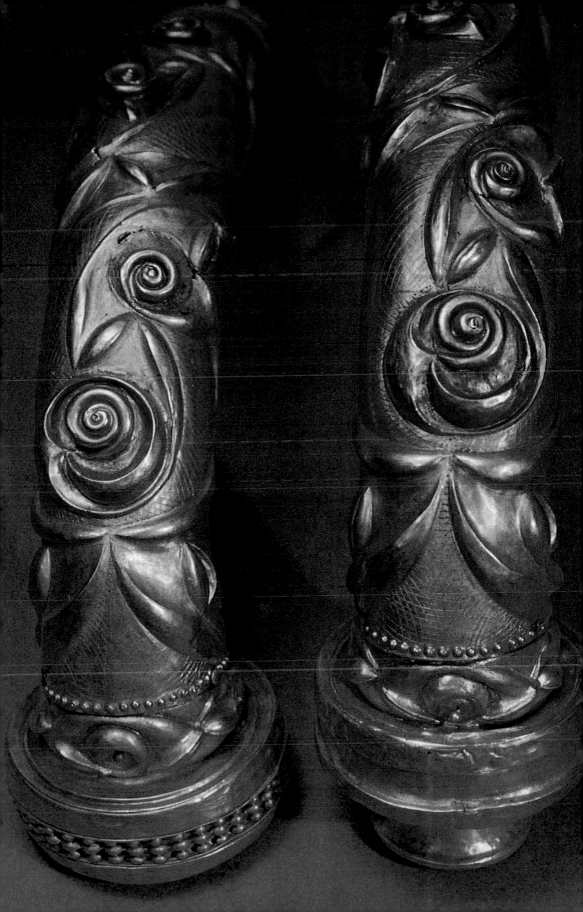

*Pl 4 Detail of the clasp of a gold necklace found with the Broighter Hoard. The clasp is of a type that was used widely in Mediterranean lands. The necklace was probably made in Roman Egypt during the first century BC.*

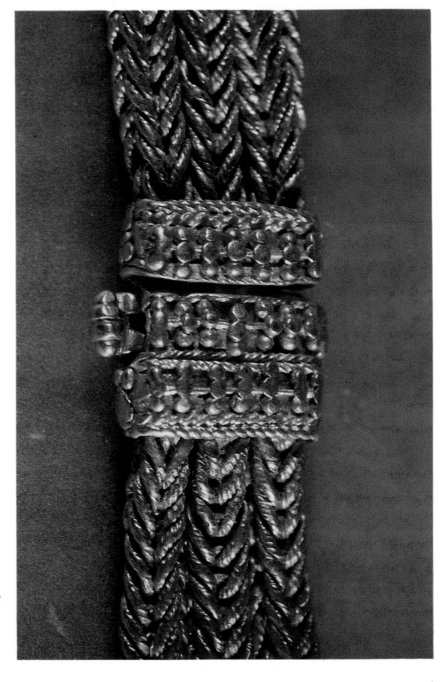

*Pl 5 (Facing page) Gold model of a boat complete with mast, rudder, and oars, which formed part of the Broighter Hoard. The vessel represented is an ocean-going craft, which would have been capable of undertaking long sea voyages.*

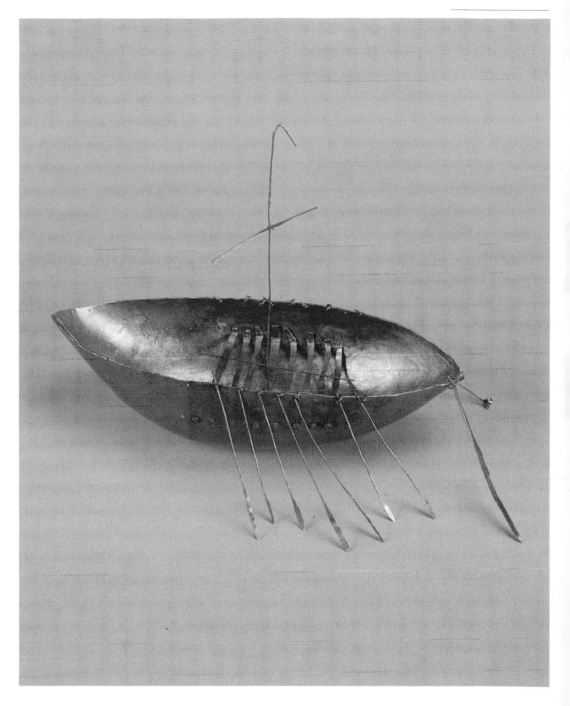

*Pl 6 Gold bowl —
probably a model of a
cauldron — found
with the Broighter
Hoard. Tales of
magical cauldrons,
which abound in early
Irish mythology, serve to
underline the ritual
nature of the hoard.*

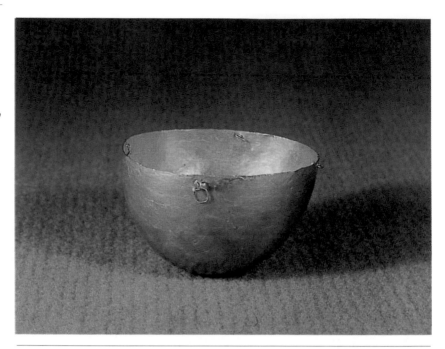

*Pl 7 Bronze vessel,
which contained a
cremation burial,
discovered within a
hill-fort at Fore, Co
Westmeath. One of two
handles in the form of a
bird head is now lost.
Like the Keshcarrigan
vessel (Pl 8), it
probably represents an
import from southern
Britain around the
time of Christ.*

*Pl 8 (Facing page)
Bronze vessel with a
handle in the form of a
bird head found at
Keshcarrigan, Co
Leitrim. The vessel was
probably imported from
southern Britain
during the early part of
the first century AD.*

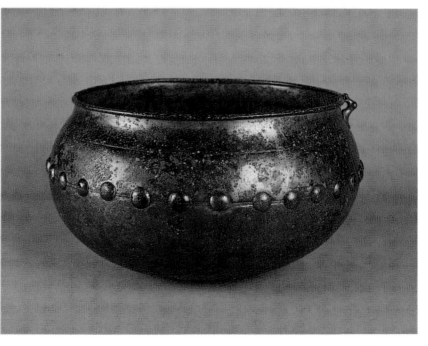

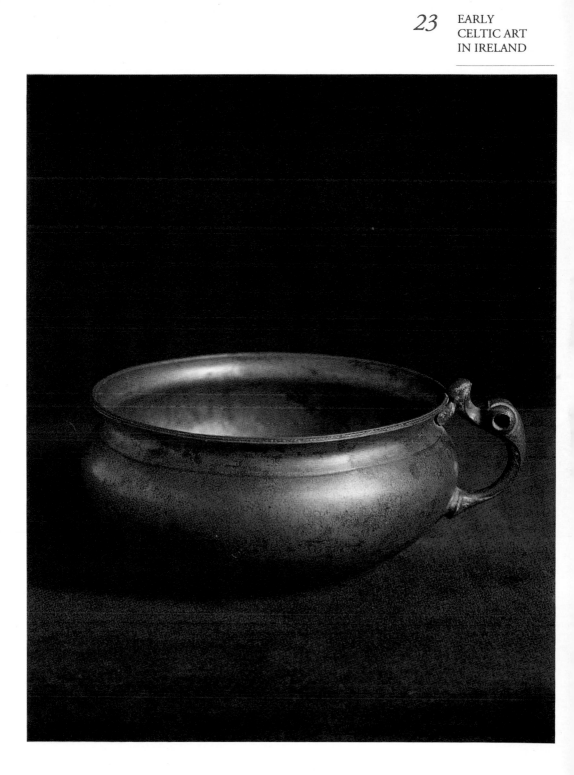

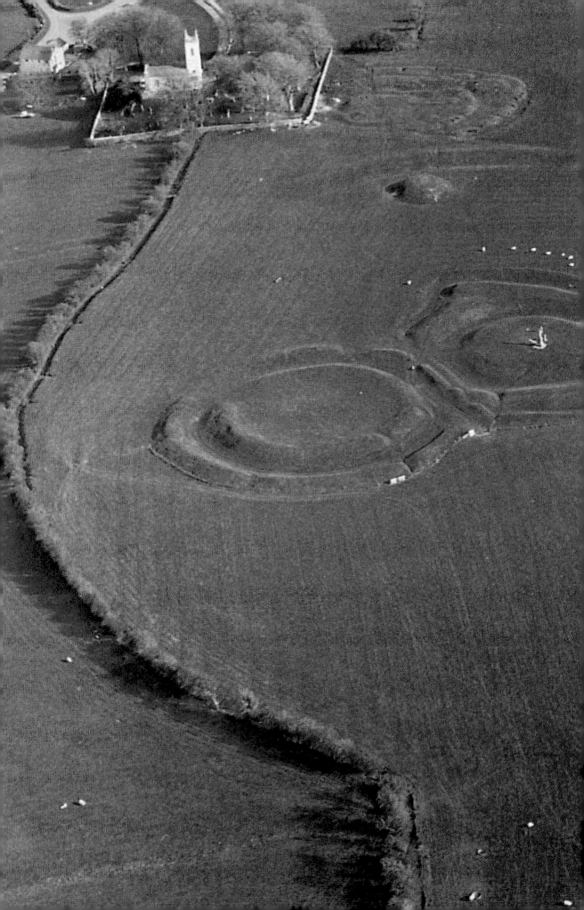

*Pl 9 (Previous spread) Aerial view of earthworks on the Hill of Tara, Co Meath. From early prehistoric times the hill appears to have been a centre of religious and political importance. The site was largely abandoned around the time of the introduction of Christianity during the fifth century. The former importance of the site may be judged from the fact that during the early medieval period kings who claimed to be the overlords of Ireland styled themselves 'King of Tara'.*

*Pl 10 Bronze bracelet found during drainage work along the River Boyne at Ballymahon, Co Meath. A bird head, set within a field of red enamel, is a form of decoration that was employed by Irish craftworkers over a long period. The bracelet may date from the sixth or seventh century AD.*

*Pl 11 Three-faced stone head of a Celtic deity found at Corleck, Co Cavan. In Ireland the number three had particular significance in Celtic religion. This fact is central to the tradition surrounding St Patrick and the three-leaved shamrock.*

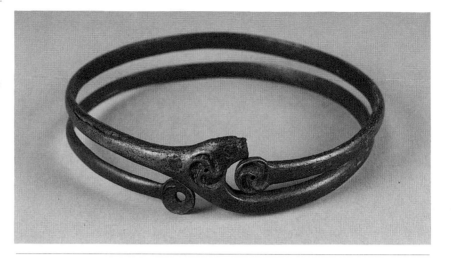

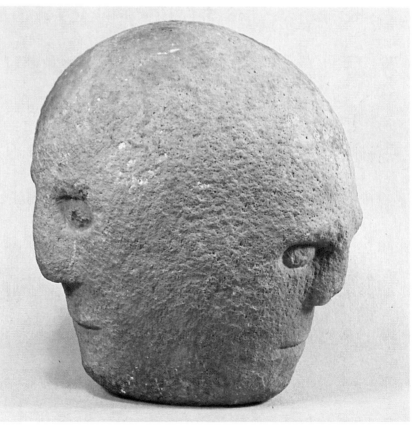

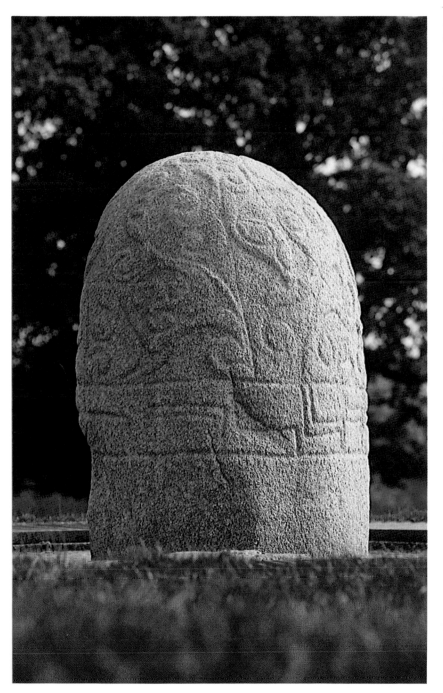

*Pl 12 Decorated
standing stone at
Turoe, Co Galway.
The surface is covered
with raised curvilinear
decoration. It is likely
that the stone was
erected around the time
of Christ, probably for
ritual purposes
concerned with fertility.*

*Pl 13 Pair of decorated bronze bridle-bits found in a bog at Attymon, Co Galway. Dating from around the second or third century AD, they would have been used to harness a pair of chariot ponies.*

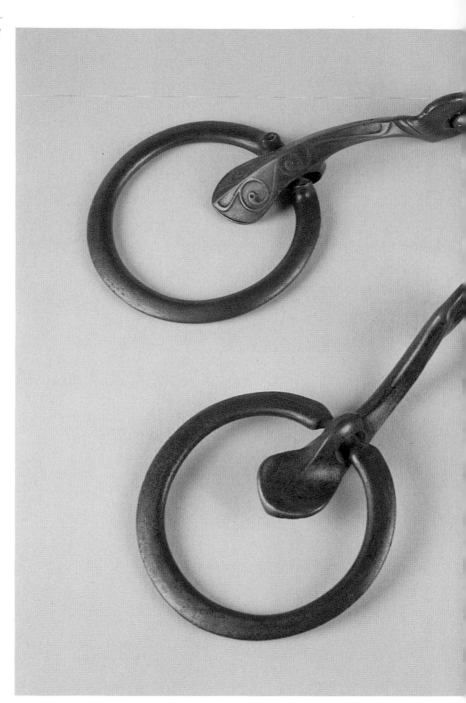

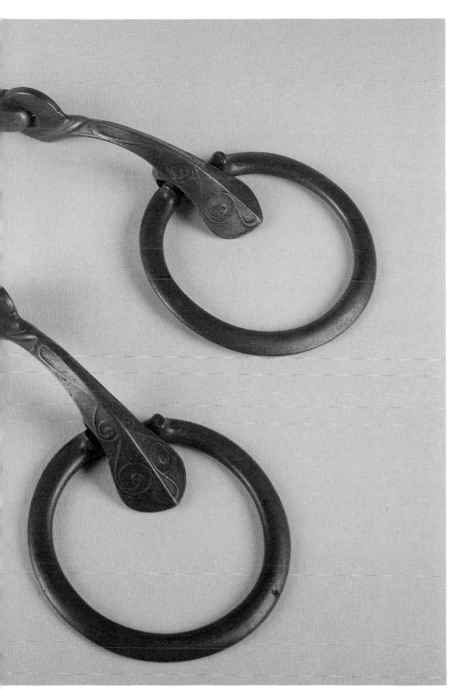

*Pl 14 Gilt bronze brooch with an oval setting found at Newgrange, Co Meath. The site is a Late Stone Age passage-tomb, which the pagan Irish living thousands of years after its construction believed to be the residence of a god. The brooch is one of many votive deposits of Roman objects left at the tomb between the first and the fourth centuries AD.*

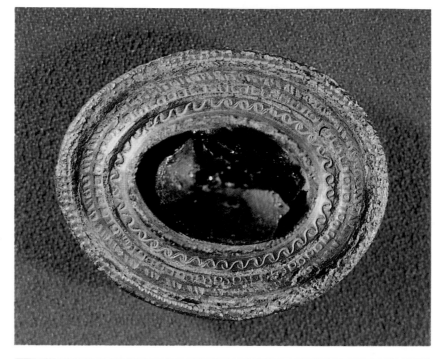

*Pl 15 The Tara Brooch is one of the great masterpieces of early medieval art. Made during the eighth century of silver-gilt with gold filigree, amber and glass ornaments, it demonstrates the manner in which Germanic, late Roman and Ultimate La Tène designs were fused into a new art style in Early Christian Ireland.*

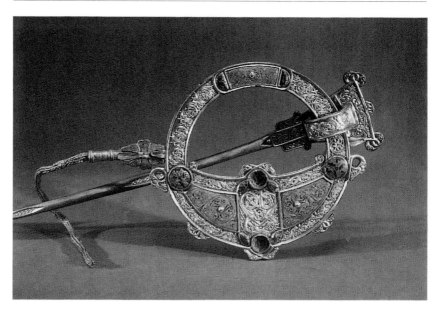

*Pl 16 (Facing page) Detail of the back of the Tara Brooch. On a triangular panel, delicate Ultimate La Tène designs in copper can be seen set against a silver background.*

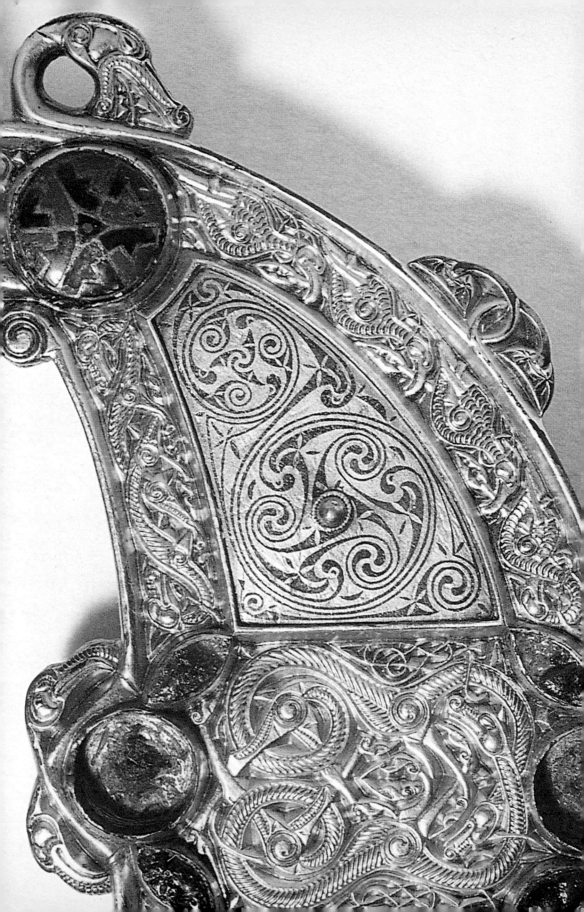

*Pl 17 Decorated page
from the Book of Kells,
written around AD
800. Known as the
chi-rho page of St
Matthew's Gospel, it
refers to the birth of
Christ. The extensive
use of Ultimate La
Tene designs is
immediately apparent
and demonstrates the
importance of the style
to the artists who
produced illuminated
manuscripts.*

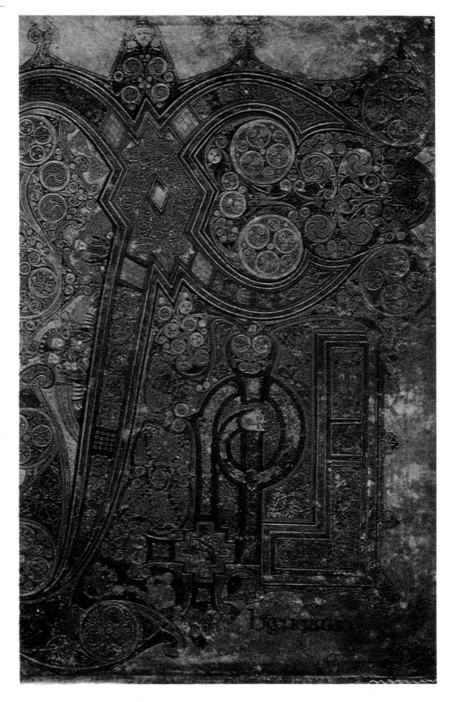

*cont. from p 16*

bird, whose eye sockets probably held red enamel.

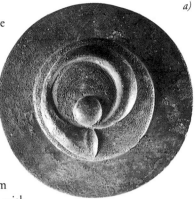

*a)*

Boxes and cylindrical mounts similar to those from Somerset have been found elsewhere in Ireland (Photo 10), and they illustrate the range of techniques in use by Irish craftworkers before the end of the first century AD. A similar though relatively plain box was recovered from the River Shannon at Athlone. Decorated on the base with a large plain boss, centrally placed, and on the lid with a smaller boss located off centre, it contained three fragments of scrap bronze, one of which may be a binding strip from a shield.

A beautifully decorated lid was found in a bog at Cornalaragh, Co Monaghan. This has a raised circular area, at the centre of which is a smaller raised disc bearing an openwork design. An S-shaped form divides the disc symmetrically, and two opposed spiral patterns with clubbed terminals emerge from the edge at right angles to this. The area surrounding the central disc is pierced with a lattice arrangement of lozenges with curved sides.

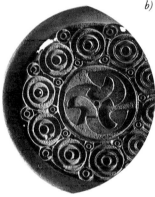

*b)*

A mount from Ballycastle, Co Antrim, which compares closely to the two small cylindrical mounts or boxes from Somerset, has a bird head as its central design. The design is reserved, while the background has been cut away to take red enamel. There is a continuous series of rectangular cells around the central design and around the side of the mount, which also held red enamel.

A circular lid found near Navan Fort is similar in size to the larger Somerset boxes. The central design is a reserved triskele in a field of red enamel. This is surrounded by a series of large and small reserved concentric circles, also in a field of red enamel.

*c)*

*Photo 10 Three ornamental bronze boxes that show the variety of techniques available to Irish Celtic craftworkers during the early centuries AD. The decoration on the Somerset box (a) was produced by hammering; that on the Navan box (b) was reserved after the background was partially cut away to act as a field for red enamel. On the Cornalaragh (Co Monaghan) box (c) the background has been fully removed to produce an openwork design.*

### Decoration with glass and enamel

The use of large areas of red enamel on a number of these objects deserves further mention. The La Tène Celts on the Continent, and to a smaller extent in Britain, used inlays of red Mediterranean coral to decorate fine metalwork. This practice is not known in Ireland. However, substitute materials — red glass or red enamel — were used to decorate a number of objects, especially those produced during the first century AD.

Two different methods were used. In one, the material was moulded separately before being attached, as for example on the small cylindrical mount from Somerset and on a pin from Grange, Co Sligo. When this technique is used the material is likely to be red glass rather than true enamel. A large block of the raw material found at Tara (Pl 9) was discovered to be of Italian origin, and most of the red glass analysed from objects produced in Britain and Ireland during the period comes from the same source. In the second technique, known as champlevé, molten enamel is poured into specially prepared cells in the metal, to which it bonds. Real enamel must be used in this technique, as the red glass changes colour to green if it is melted. A good example of true enamelling is to be found on the Navan box.

Enamel is used on objects such as the tubular spear-butts and the Petrie Crown, but sparingly. On one unprovenanced spear-butt, enamel is placed in a cross-hatched field. This may be compared with studs on the horned helmet found in the River Thames, whose surfaces were cross-scored to take enamel. The materials used and the nature of the art appear to link all three objects, and a British background is again emphasised.

*Photo 11 Found near Newry, Co Down, this decorated bronze armlet was imported from eastern Scotland during the early centuries AD.*

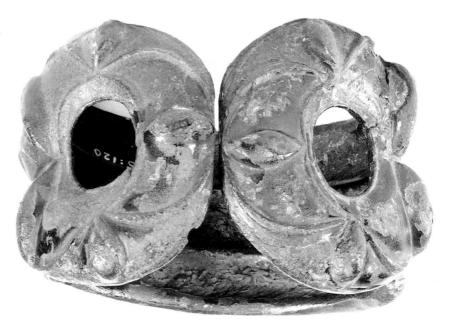

A large cast bronze armlet with circular terminals found near Newry, Co Down, is an import from eastern Scotland (Photo 11). The decoration is dominated by a repetitive series of transverse lentoid bosses. The form of a bracelet found at Ballymahon, Co Meath, may have been inspired by coiled-snake bracelets made in northern Britain during the early centuries AD; it is, however, an Irish piece, which may date from as late as the sixth or seventh century AD (Pl 10). There are two reserved bird heads, similar to that on the Ballycastle mount. They may originally have had surrounding inlays of red enamel. A few other Irish bronze bracelets are known, and examples made from fossil wood, such as jet and lignite, also appear to have been in use during pagan times. Bracelets made from blue and clear glass also occur.

Glass beads were being manufactured in Ireland from at least the Late Bronze Age. Nine large ring-beads, with whirl or ray designs, have been found, which are a well-known Late La Tène continental type. These appear to have been imported, although the type may have been imitated here. Beads of clear or blue glass, sometimes with inlaid yellow spirals, were also in use. This type probably originates in south-west England, and a grave at Loughey, Co Antrim, in which 150 beads were found, is probably of a person from that part of Britain.

Dumb-bell beads were also used, and, although examples from Britain are also known, they are essentially an Irish form. Three were found in association with a series of decorated bone objects in a neolithic passage-tomb at Loughcrew, Co Meath, known as cairn H. Most of the objects are fragmentary, but included were fourteen pieces of bone combs, many of which bore incised curvilinear decoration. The type of comb is of Scottish origin.

A carefully worked plain rectangular bone plaque also found in cairn H is likely to be a gaming piece. It may therefore be related to two gaming pieces found at Cush, Co Limerick, and Mentrim Lough, Co Meath. Like some of the Loughcrew combs, these pieces are decorated on each of the main surfaces with compass-drawn incised lines. One side of the Cush example has six concentric circles, linked by stippled ovoid forms. The other surface has five concentric circles joined by cross-hatched trumpet shapes.

One side of the Mentrim Lough example has a design shaped like two opposed parasols against a background mesh of closely spaced compass-drawn arcs. The background decoration relates the object to the incised decoration on the Broighter collar. A variant mesh of arcs is found on the other main surface of the plaque, where it is used to highlight the body of a highly stylised horse. The subject of the design, as well as the techniques employed to decorate it, links the piece to the Broighter collar.

Two pins, one with cross-hatching, were also found inside cairn H; but the most remarkable bone objects discovered were the so-called bone slips (Photo 12). Made from animal ribs, the slips are generally rectangular in shape with rounded or pointed ends. Of a total of 4843 fragments that have been reported, 4350 can be accounted for, of which 138 are decorated. A variety of designs is employed, including lotus-like forms, continuous broken-backed scrolls, comma curves, background dotting, concentric

*Photo 12 Decorated bone slip dating from the first century AD, found within a passage-tomb at Loughcrew, Co Meath; the object may have been used in fortune telling. The design is similar to that on a possible gaming piece found in a burial at Cush, Co Limerick.*

*Photo 13 Incised line and stippled decoration on the handle of a spoon-like object, the find place of which is not known. The object is one of a pair; the other is perforated near the edge of the 'bowl' and bears a different design. A ritual rather than a domestic function appears likely.*

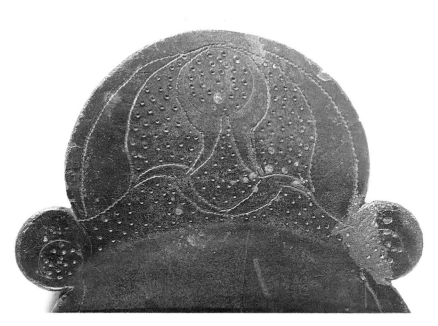

overlapping arcs, circles asymmetrically placed within each other, and spindly knob-ended triskeles.

The decoration can be compared not only to that on the other bone objects but also to that on a range of metal objects such as the Broighter collar and Petrie Crown and the tubular spear-butts. It is also similar to incised designs on a number of bronze spoon-like objects (Photo 13), which, like the bone slips, may have had a ritual function. The spoons appear to occur in pairs, one of each pair having a perforation in the bowl close to the edge. Six examples are known; one is likely to be an import from southern Britain, whereas the others are of a form current in Scotland and Ireland around the time the Loughcrew bone slips were made. External artistic comparisons have been drawn between the bone slips and objects found in northern and south-western Britain.

*Photo 14 Decorated bone slip from Loughcrew, Co Meath. The freehand drawing of a deer may suggest an association with the Celtic horned god Cernunnos.*

Like the bronze 'spoons', the function of the bone slips is a mystery, but their presence inside a passage-tomb is likely to be significant. It has been proposed that the slips were trial pieces on which metalsmiths worked out their designs. However, there is no evidence of metalworking at Loughcrew. Although a portion of a compass was reported to have been found, and it appears that the slips were decorated on site, the location can hardly be regarded as a workshop. A ritual function is perhaps more likely, and the objects may have been used in some activity such as divining or fortune telling (Photo 14).

### Figures and heads

Ancient megalithic tombs were regarded by the Celts as the homes of the gods. Perhaps the best known of these tombs is that at Newgrange, Co Meath, which was associated with the powerful Celtic god known as the Daghdha.

Some representations of Celtic gods have been found in Ireland. Most are of stone, although wooden examples have also survived. A remarkable wooden idol found in a bog at Ralaghan, Co Cavan, consists of an elongated figure with a hole into which a wooden phallus was once fitted (Photo 15). The carving is remarkably similar to Gallo-Roman wooden figures found at the source of the River Seine; however, it is not essential to view the Ralaghan figure as coming directly from that source, as both may derive from a common ancestor dating back at least to the Middle Bronze Age. The same may be said of a wooden figure found near a crannóg or lake-dwelling at Lagore, Co Meath (Photo 16), which compares with a figure from a Gaulish sacred well at Montbouy, France.

Examples of stone heads, some of which have a number of faces, are to be found throughout the Celtic world. The finest example from Ireland is the finely carved three-faced head from Corleck, Co Cavan (Pl 11). A stone figure from Tandragee, Co Armagh, and carvings found on Boa Island, Co Fermanagh, are also likely to belong to the pagan Iron Age. A stone head said to have been found within an Early Bronze Age stone circle at Beltany, Co Donegal (Photo 17) is likely to be of pagan Celtic origin. The precise cultural affinities of this material are difficult to establish, but both continental Celtic and Romano-British connections have been pointed to.

Large decorated standing stones have been found at Turoe, Co Galway (Pl 12), Killycluggan, Co Cavan, and Castlestrange, Co Roscommon. A related example has been found built into a church wall at Derrykeighan, Co Armagh. The decoration generally consists of leafy curvilinear designs, which may be compared to those found on metalwork such as sword scabbards and to some of the decoration on the Broighter collar. The ornament can also be compared to that on some of the Loughcrew bone slips. The Turoe ornament was produced by chiselling away the background, whereas on the other examples it is incised. A third-century BC Breton background has been proposed for the Irish examples, but comparisons with later British Celtic art, particularly that on certain mirrors, have also been pointed out. Whatever the foreign

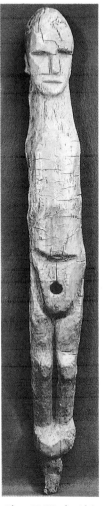

*Photo 15 Wooden idol found in a bog at Ralaghan, Co Cavan. Figures of this type may have been in use over a wide area since the Bronze Age. The Ralaghan figure is remarkably similar to Gallo-Roman figures found at the source of the River Seine.*

*Photo 16 Wooden figure found near a crannóg at Lagore, Co Meath.*

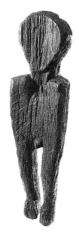

background of the decorated stones may be, it should be stressed that this is an entirely native form, and a date in the centuries on either side of the birth of Christ seems most likely.

It seems probable that these stones had a ritual purpose, and it is interesting to note that a decorated stone shaped like that from Turoe played a central role in the rituals performed at Delphi in Greece. Known as the Omphalós or 'navel', it was regarded as the centre of the universe.

*Photo 17 Stone head said to have been found within a stone circle at Beltany, Co Donegal. The figure appears to be wearing a collar. It may be compared to a more naturalistic head from the area of the Czech town of Mšecké Žehrovice that dates from the third or second century BC.*

18

19

20

21

*Photo 18 Enamelled decoration is rare on Irish bridle-bits; this example is from Lough Beg, Co Antrim.*

*Photo 19 The shank of a Y-shaped piece from Attymon, Co Galway, bears raised line ornament in the form of three running spirals, triangularly juxtaposed and centred on a triskele. The design compares closely with that on an object known as the Bann Disc.*

*Photo 20 One of a pair of bronze discs found at Monasterevin, Co Kildare. The curvilinear decoration may be a stylised representation of a human face. The discs may have been suspended from the sides of a chariot.*

*Photo 21 Hoard from Killeevan, Anlore, Co Monaghan, containing a bronze bridle-bit with enamelled ornament and a decorated bronze disc, thought to be a decorative mount either for a horse harness or a chariot.*

## Horses and chariots

It is said that Cú Chulainn, the mortally wounded hero of the 'Táin Bó Cuailgne', tied himself to a standing stone for his final encounter with his enemies. The tale, written down in the eighth century, preserves by way of oral tradition a window into the world of the pagan Celts in Ireland. Regularly the hero is described going into battle on a chariot driven by Laeg, his charioteer. Chariots were used by the continental Celts from Early La Tène times and were present in burials, particularly in eastern France and in the Yorkshire area of Britain. Chariot burials have never been found in Ireland, but other finds indicate that light vehicles in paired draught, which were surely chariots, were in use from at least the time of Christ.

A small number of fittings have been found that may come from chariots. A 'terret' or ring through which the reins would pass, found in Co Antrim, is of a type associated with chariots in northern Britain. Linch-pins, used to attach the wheels, are known from Dunmore, Co Galway, and Portstewart, Co Derry. It has been suggested that two hollow mounts found at Lough Gur were hand-holds attached to the rear of a chariot to

*Photo 23 Stone pillar
from Aglish, Co Kerry,
bearing an ogham
inscription, together with
a Maltese cross, spear, and
swastikas, which were
applied later. The
inscription is now
incomplete; it reads
...MAQI MAQ(I...)
GGODIKA. The spear
represents the weapon that
pierced the side of Christ;
the swastikas are symbolic
of the resurrection. Dates
from the fifth to sixth
century AD.*

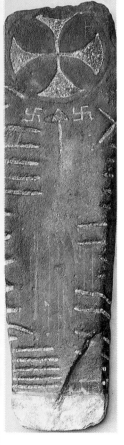

Five safety-pin brooches or 'fibulae' complete the assemblage. These consist of a pair of large dolphin brooches and a smaller example of the same type. The small example has inlay of blue enamel and, together with a similar brooch found near Cashel, Co Tipperary, is the earliest example of blue enamel in Ireland. The remaining two brooches are of the Langton Down and thistle brooch types. All five originate in a Roman milieu on the Continent and have their immediate place of origin in south-east England, although they probably reached Ireland via the north of England.

It has been suggested that the Lambay burials represent those of Brigantian refugees who fled the Roman conquest of their territory in the years between AD 71 and 74. The presence on Lambay of objects from south-east England as well as Brigantia would accord well with the historical evidence. The Roman invasion was preceded by a civil war among the Brigantians, caused by the handing over of a Belgic leader to the Romans. This picture is likely to be somewhat simplistic, however. Lambay Island is near the great promontory fort at Loughshinny, Co Dublin, from where there is evidence of settlement and manufacturing during the first century AD, together with evidence of trade with the Roman and Romano-British world.

### The Roman influence

Although the Roman army never invaded Ireland, it is certain that Roman traders and merchants were active here during the centuries following the invasion of Britain. Roman burials have been found at Stonyford, Co Kilkenny, and Bray Head, Co Wicklow. Numerous stray finds and hoards of Roman objects have also been found, representing either casual losses or deliberate concealment of valuables. Several finds of Roman objects have been discovered at Newgrange (Pl 14), and these must surely represent votive deposits. Whether these were placed there by visiting Romans or by native Irish is not clear.

The most recently found material clearly consists of prestige objects, including gold, silver and bronze coins that date from between the first and fourth century AD, and jewellery, including gold and silver rings, gilt bronze brooches and bracelets that appear to date from the fourth century AD. This was the period when the empire was in decline and the Irish were embarking on colonial enterprises in Scotland, Wales, and Cornwall. Indeed the raiding activities of the Irish contributed to the collapse of Roman rule in Britain. For the previous few hundred years Ireland had been increasingly influenced by the Roman world through the medium of trade and possibly through Irish warriors serving as mercenaries in the Roman armies. Through their colonies, Irish contacts with Romano-British culture reached a pinnacle at this time. One feature of the period was the development of the runic alphabet known as 'ogham', based on the Roman alphabet (Photo 23). This period of Romanisation in Ireland can be seen as culminating in the fifth century AD with the introduction of Christianity, by then the official religion of the empire.

A hoard of Roman silver found at Balline, Co Limerick (Photo 24), contained both

chopped-up tableware, presumably the contents of a villa, and ingots, which may have been either the property of a merchant or the stored wealth of a Roman landowner. St Patrick, who is largely credited with the introduction of the Christian faith, was himself first taken to Ireland as a slave, having been captured on such a raid. It is worth recalling, however, that before St Patrick's mission the Pope had already despatched Bishop Palladius to minister to the Christian community then established in Ireland.

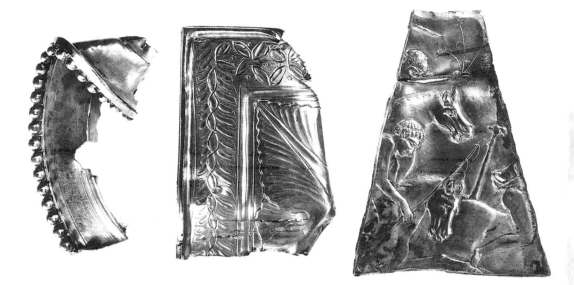

*Photo 24 Hoard of chopped-up Roman tableware found at Balline, Co Limerick, part of a silver hoard that also contained ingots. The hoard is likely to have resulted from an Irish raid on Roman Gaul during the fourth century AD.*

## Ultimate La Tène art

At around the time that the Irish were settling in northern and western Britain, Anglo-Saxon settlers were invading Britain from the east, and they brought with them the animal art of northern Europe. This had roots in common with Scythian art, which had contributed to the development of Early La Tène art. During the Christian era a new artistic tradition arose in Ireland from a fusion of motifs and techniques drawn from Germanic art with artistic traditions taken from the late classical world of the western empire. From the widespread Christian communities of the eastern Mediterranean came motifs from the Coptic, Syrian and Byzantine churches. The core tradition to which all these new innovations were fused was Ultimate La Tène art.

A whole range of new tools and objects of personal adornment, drawn mainly from the late Roman world, was introduced along with these new ideas. This included new pin and brooch types. Of particular importance was the penannular brooch, so called because of the gap in the ring. Certain brooches were decorated on the terminals with stylised representations of animal heads. Known as the zoomorphic penannular brooch, this type developed out of Roman military brooches in northern Britain (Photo 25). A

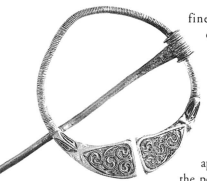

fine example dating from the second century AD was found in a Roman fort at Newstead, Scotland. From northern Britain the type was introduced into Ireland, where it underwent a long series of developments.

The decoration on a standing stone from Mullaghmast, Co Kildare, appears to illustrate the developments of the period (Photo 26). Erected during the sixth century AD, it has an overall carved decoration. Many of the motifs are those with which we are familiar from pagan Iron Age times. Included are the triskele, trumpet motifs, spirals with clubbed terminals, and leaf-comma motifs. A band of zigzag ornament that originally ran around the base of the stone is reminiscent of decoration on the base of the Turoe Stone. A panel contains two highly stylised animal heads, comparable to those on the terminals of zoomorphic penannular brooches. There are also the remains of an incised saltire, a design commonly employed on the back of the terminals of such brooches. Elsewhere on the stone there is a pointed oval containing two spirals with clubbed terminals, the whole being set within a further pointed oval. This is identical in design to that found on an unprovenanced example of a latchet brooch, another of the newly introduced types, which has extensive areas of red enamel (Photo 27).

There are two panels of highly geometric incised decoration, probably deriving from designs employed on late Roman mosaics. Within an oval panel, framed in

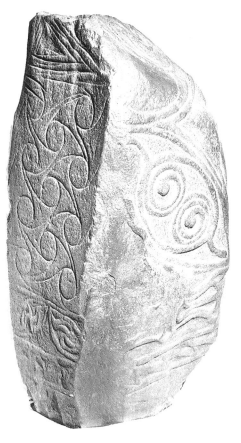

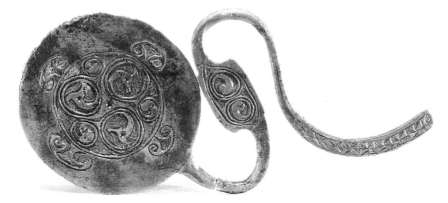

*Photo 27 Bronze
enamelled latchet
brooch manufactured
between the fifth and
seventh centuries AD.
The main ornament,
which consists of spirals
ending in bird heads, is
characteristic of La
Tène art in Ireland.
This type of brooch was
not as long-lasting as
the penannular brooch
and related forms.*

relief, is a design based on interlocking peltae and palmette-derivatives. The second is a large rectangular panel that is also decorated with peltae or palmette-derivatives.

The practice of erecting standing stones extended back as far as the neolithic period. The Mullaghmast stone has an important transitional position, as it links the pre-Christian sculptural tradition with that which evolved by way of cross-inscribed pillars and decorated slabs to culminate in the great high crosses of the Christian era.

The latchet brooch appears to have fallen out of fashion quickly. The penannular brooch, however, continued to be popular until the end of the millennium and spawned a whole range of related forms. The pinnacle of artistic perfection and technical excellence was reached in one outstanding brooch, of a type known as pseudo-penannular. This is the so-called Tara Brooch, which dates from the eighth century (Pl 15). It is a product of the golden age of Early Christian art and shows to perfection the manner in which all the new elements were reinterpreted and combined. The back of the brooch is decorated extensively with Ultimate La Tène designs, which are artistically supremely accomplished as well as technically innovative (Pl 16).

Other important pieces from the eighth century, such as the Ardagh Chalice and the Lough Kinale book shrine, also make extensive use of Ultimate La Tène designs. Particularly favoured were spirals that terminated in bird heads. On the Ardagh Chalice the names of the apostles, incised below the rim, are highlighted by the use of background stippling, a technique that continued in use from the earliest La Tène times in Ireland. The names, in Latin, are written in a style close to that used on some of the manuscripts of the period, particularly the Book of Lindisfarne.

The ogham alphabet continued to be used in Ireland long after the introduction of Christianity. It was an unwieldy script, however, unsuited for the writing of books. The Roman alphabet proper was adopted and developed along new lines in Ireland (Photo 28). Church manuscripts, in particular Gospel books, as well as mythological, historical, annalistic and genealogical works, were produced in monastic scriptoria. The more

*Photo 28 One of a number of seventh-century wooden waxed tablets found in a bog at Maghera, Co Derry. The leaf shown here bears a Latin text that appears, mainly, to be an extract from the rules of Latin grammar. The text was written on the soft wax using a pointed stylus. It is an exercise book in which the text could be smoothed and the surfaces re-used. The tablets are a Roman type, and similar examples, dating from the first and second centuries, have been found in London.*

important books, particularly Gospel books, came to be elaborately illuminated both in Ireland and in those monasteries that had been founded by Irish monks in northern England and Scotland (Pl 17). The art of the manuscripts, which is heavily reliant on Ultimate La Tène forms, is similar to that which occurs on objects such as the Tara Brooch.

In the second half of the first millennium AD, mainly through the medium of the manuscripts but also through religious metalwork such as shrines, Ultimate La Tène art was returned to its continental homeland through the missionary efforts of Irish monks. Dispersed through a network of Irish monasteries in northern Italy, Switzerland, Austria, Germany, and France, as well as Britain, the art went on to form an important ingredient in the development of European art during the early medieval period. In this way Celtic art returned to the mainstream of European artistic development, a process that had been curtailed outside northern Britain and Ireland by the spread of the Roman empire.

# GLOSSARY

**chapes:** fittings at the end of sword scabbards to prevent the point from piercing through.

**dumb-bell beads:** glass, stone or bone beads consisting of two conjoined spheres, somewhat like a weight-lifter's dumb-bell, found in La Tène contexts in Ireland. Usually the beads are perforated across the middle in the manner of toggles.

**fused-buffer terminals:** many Celtic collars, such as the Broighter collar, have terminals that resemble the buffers of an old-time steam engine. On one of the Clonmacnoise collars the terminals are continuous, giving the impression that the buffers are fused.

**lentoid:** a pointed oval shape formed by intersecting arcs.

**palmette:** a schematic representation of the oriental tree of life, which the Celts borrowed from the Etruscans. In later Celtic art the motif is often transformed into the stylised outline of a face, as for example on the Attymon bridle-bits (Pl 13).

**pelta:** basically a mushroom shape, it is a simplified form of the palmette motif, and is particularly common in Ultimate La Tène art. Four pelta motifs are diagonally opposed around the edge of the main design on an unprovenanced latchet brooch (Photo 27).

**repoussé:** a metalworking technique whereby a design is hammered up from behind. The decoration on the discs found at Monasterevin (Photo 20) was achieved by this technique.

**reserved decoration:** the decoration that remains after the background is reduced, usually for use as a field for enamel. It can be seen on the Navan box (Photo 10b).

**spear-butt:** a metal fitting that protected the end of a spear-shaft and acted as a counterweight to the spearhead. Four basic types were used in Ireland during the Early Iron Age, one of which was shaped like a modern doorknob.

**triskele:** a motif formed of three scrolls that spring from the same point and turn in the same direction. A triskele forms the main design on the unprovenanced latchet brooch (Photo 27).

## SELECT BIBLIOGRAPHY

Megaw, R, and Megaw, V, *Celtic Art from its Beginnings to the Book of Kells,* London, 1980.

Raftery, B, *A Catalogue of Irish Iron Age Antiquities* (2 vols), Marburg, 1983.

Raftery, B, *La Tène in Ireland,* Marburg, 1984.

Ryan, M (ed.), *Treasures of Ireland: Irish Art, 3000 BC–1500 AD,* Dublin, 1983.